FrEaK sHoW: SiDeShOw BaNnEr ArT

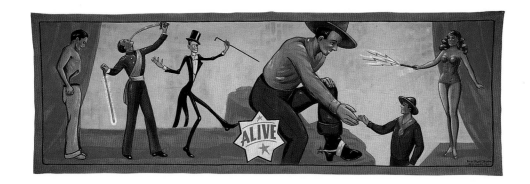

BY CARL HAMMER AND GIDEON BOSKER

CHRONICLE BOOKS

SAN FRANCISCO

THE AUTHORS WISH TO ACKNOWLEDGE KIRSTEN PIERCE FOR HER PAINSTAKING AND THOROUGH RESEARCH EFFORTS ON BEHALF OF THIS PROJECT AND LENA LENCEK FOR HER REVIEW AND EDITORIAL COMMENTS ON THE ORIGINAL MANUSCRIPT. WE WOULD ALSO LIKE TO THANK BANNER PAINTER JOHNNY MEAH FOR HIS INSIGHTS AND ORAL HISTORY RECOUNTING THIS PERIOD IN AMERICAN ART. SPECIAL THANKS GO TO JERRY SMITH, WHO HAS BEEN SUCH A LOYAL AND EFFECTIVE GALLERY ASSISTANT OVER THE YEARS, AND OUR EDITOR, CHARLOTTE STONE OF CHRONICLE BOOKS, WHOSE SUGGESTIONS AND GUIDANCE WERE INVALUABLE, AND CONTRIBUTED GREATLY TO THE DESIGN AND CONTENTS OF THIS BOOK. ⊙ FINALLY, HERE'S TO THE WARD HALLS AND CHRIS CHRISTS; TO THE SNAP WYATTS AND FRED JOHNSONS; TO PRISCILLA THE MONKEY GIRL AND ALL THE FREAKS AND GEEKS EVERYWHERE. THANK YOU.

Book and cover design: Marion English, SlaughterHanson. Unless otherwise indicated, the banners in this book appear courtesy of the Carl Hammer Gallery. Front cover: "Sweet Marie," Snap Wyatt, 96"x120", c.1940s, collection of Dean Jensen. Page 3: "ALIVE" Cavalcade Banner, Snap Wyatt, 84"x246", collection of Steve Havens. Page 6: Detail of "Lobster Boy," Snap Wyatt, 248-1/2"x104".

Library of Congress Cataloging-in-Publication Data:
Bosker, Gideon
 Freak show:sideshow banner art/by Gideon Bosker and Carl Hammer.
 p. cm.
 ISBN: 0-8118-0707-X.
 1. Carnival banners—United States. 2. Folk art—United States.
I. Hammer, Carl. II. Title.
NK5030.B67 1996 95-35899
741.6' 7'0973—dc20 CIP

Distributed in Canada by Raincoast Books, 8680 Cambie Street, Vancouver, B.C., V6P 6M9.
Chronicle Books® is registered in the US patent and trademark office.

10 9 8 7 6 5 4 3 2

CHRONICLE BOOKS
85 SECOND STREET
SAN FRANCISCO, CA 94105
WEB SITE: WWW.CHRONICLEBOOKS.COM

CONTENTS

LOBSTER
BOY
24IN LONG

To my daughter Bianca, for teaching
me what it means to be "Positively Alive!" –GB
To Yolanda, who brings both aggravation and
happiness to my life. –CH

LITTLE DID I KNOW back in 1983 when picking up and browsing through a copy of *Life* magazine the degree to which my life would be impacted by its contents. A wonderful photo sequence of a sword-swallowing performer and another inset photo of an oversized painted canvas of a giant snake, emblazoned with the word "ALIVE," riveted my attention. Not long after, I found myself driving to "Showtown, USA," Gibsonton, Florida, to meet the performer/banner painter Johnny Meah. I was in for a journey of greater proportions than I had dreamed, for I was soon to discover a way of life and life experiences that had relatively little connection to the values and aesthetics of my own. Johnny Meah, the last of the master banner painters, brought all of the sideshow world to life for me. I felt privileged because of my discovery, yet I sensed my outrage too by the art canon's neglect of his (and his fellow artists') level of knowledge, genius, and talent.

THERE IS A CONSIDERABLE amount of discussion in my profession about how one develops an "eye"or a certain level of aesthetic judgment/connoisseurship. I know that a huge door of influence was opened for me from the above experience. It provided me with unique subsequent opportunities, and the roads I've travelled have not been the same since.

CARL HAMMER, 1995

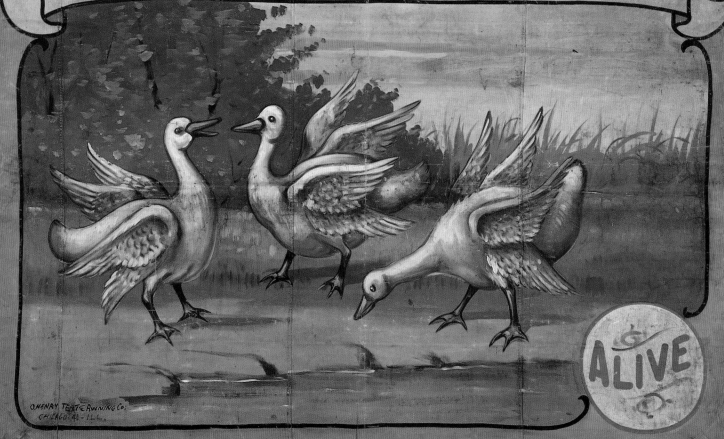

I N T R O

WITH ITS RETINA-SEARING COLORS, FREAK
APPEAL, AND BOMBASTIC RECONSTRUCTIONS
OF HUMAN AND ANIMAL ANATOMY, THE CIRCUS
SIDESHOW BANNER PREYED ON OUR INEXHAUSTIBLE
CURIOSITY TO COME FACE TO FACE WITH THE GROTESQUE
AND THE UNIMAGINABLE. THROUGHOUT THE CIRCUS' HEYDAY
FROM THE LATE NINETEENTH TO THE MID-TWENTIETH CENTURY,
THE SIDESHOW'S CHATTER, LURE, AND SIZZLE WERE INSISTENT, AND
THE BARKER'S PLEA WAS REMARKABLY CONSISTENT. THE PAINTED CANVAS

sideshow banner was a form of advertising, depicting the aberrant acts, human freaks, and animal curiosities — some authentic, others ingeniously fabricated — that could be found inside. Part billboard, part brochure, part the artist's unbridled fantasy, and part dreary fact, these banners celebrated the most complete congress of strange people, peerless prodigies of physical phenomena, and bizarre mutations that nature or the taxidermist's studio could concoct.

BANNERS

FOR THE TIMID, and sometimes naive, constituencies of early-twentieth-century rural America that were their principal public, these brash, Brobdingnagian paintings and the traveling exhibits they promoted did much to jazz up the soporific rhythms of small town life. Even the smallest sideshow, fair, or circus offered an explosion of amusements and frenzied spectacles, an antidote for the deadening boredom of the daily grind. A typical bannerline displayed in the

1940s or 1950s might have depicted everything from a mildly diverting sword swallower to the truly arresting and horrifying Dolty Dimples, the Personality, the Fat Girl, the Double-Bodied Wonder, the Headless Girl, the Pin-Headed Boy, the Flexible Lady, the Hindu Torcher, the Third Sex Family, the Eight-Footed Horse, the Iron Tongue Marvel, and the Four-Legged Girl, most of whom would inevitably be described as "positively alive."

THE WORD "ALIVE," in fact, was perhaps the most essential element of any sideshow banner. After all, these advertisements so stretched human imagination that the word "alive" was almost always added to confirm the attractions' authenticity. If the audience could be convinced that the sideshow attractions were alive, then they must also be real, although this was not always the case. For example, little bears with shaved faces were dressed in bonnets, gloves, and gowns and paraded as "pig-faced ladies." Frequently, taxidermists were commissioned to concoct animal oddities that probably made Charles Darwin turn

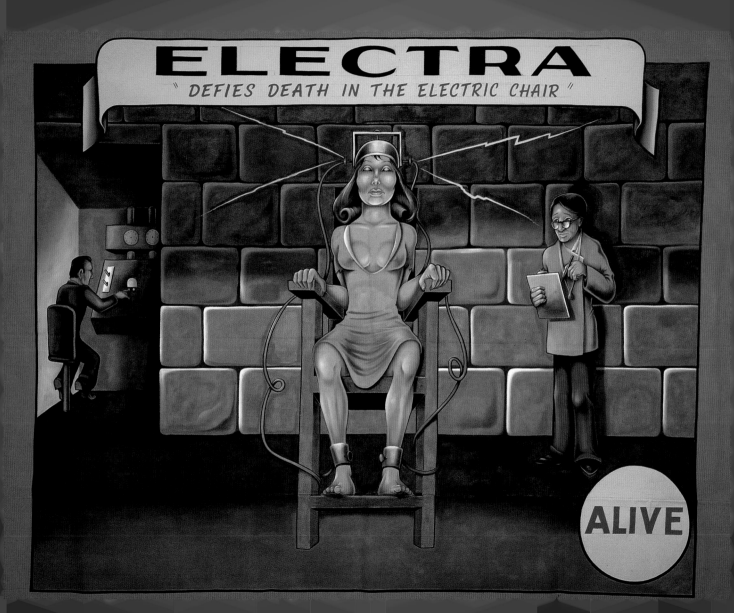

in his grave. The torsos of monkeys were combined with fish tails to create "mermaids," and artificial limbs were attached to horses, chickens, and bunnies to produce "genuine" freaks of nature. These chimeras so taxed the credulity of a generally gullible public that the proprietors felt obliged to use sideshow banners to buttress their claims that the exhibits were not only real but alive as well. In this regard, banners that hung outside the penny shows at the 1825 Smithfield Fair boasted these descriptions of the madcap amusements within the circus tent:

All Alive! No False Paintings! The Wild Indian, the Giant Boy, and the Dwarf Family! Never here before. To be seen alive!

They're all alive! Be assured, they're all alive! The Yorkshire Giantess — Waterloo Giant — Indian Chief. Only a penny!

The White Negro, who was rescued from her black parents by the bravery of a British officer — the only white Negro girl alive — the Great Giantess and Dwarf — six curiosities alive! — only a penny to see them all alive.

WHETHER DEPICTING physical perversions, feats of unbelievable physical prowess, or miracle cures, painted banners have always been instruments of allure and seduction. They first appeared in the eighteenth century among the props of European balladeers, who traveled from town to town performing melodramatic and comic tales. The most macabre depicted sensationalistic murders, generally linked to infidelity, and made an unabashed appeal to our fascination with the dark and tragic. By the early nineteenth century, the traveling menageries of England began using multiple banners with bold colors and garish images to advertise a wide variety of entertainments. There again, crude and brightly painted figures, as well as sexual content, were characteristic of this popular genre. William Howitt described the variety and impact of

banners that appeared in the 1838 Nottingham Goose Fair in the following manner:

Wombwell's Menagerie displays all its gigantic animals on its scenes; Halloway's Traveling Company of Comedians are dancing with harlequin and clown in front of their locomotive theater...panoramas and prodigies are displayed on all sides in pictorial enormity, and the united sounds of Wombwell's fine band of musicians in their Beefeater costumes...the immense pictures, suspended from lofty poles, of elephants and giraffes, lions and tigers, zebras, boa constrictors, and whatever else was the most wonderful in the brute creation, or most susceptible to brilliant coloring. The difference in scale to which the zoological rarities were then depicted on a canvas, as compared with the figures of men that were represented, was a very characteristic feature of these pictorial displays. The boa constrictor was given the girth of an ox, and the white bear should have been as large as an elephant, judged by the size of the sailors who were attacking him amongst his native icebergs.

BY THE 1870S, traveling American tent shows began to feature banners. Joseph Hallworth, known professionally as Karmi, used painted banners to advertise live magic and sword-swallowing acts, and by 1900, the medium expanded to include advertisements for thriller movies, which were presented at dime museums, circuses, showboats, and "Buffalo Bill's Wild West Show."

ESTABLISHED IN 1870, the United States Tent and Awning Company produced canvases to order fitted with grommets, rings, and pulls, from eight to sixteen feet across and usually eight feet high. By 1911, under pressure of increasing demand, they began manufacturing banners that were as large as fifteen feet high and thirty-four feet wide. Interestingly, the early banners of the mid-1800s contained far more detail, and were often much more subtly rendered, than those that followed. By the 1920s, however, banner painting had matured into a form of stylized illustration.

IN AMERICA IN 1915 Algerm W. Millard and John Bulsterbaum collaborated to produce banners for Coney Island attractions. Painted within a single frame, with the name or description of the attraction lettered on a script or scroll, these cartoon-figured canvases became the prototype for many of the banner painters who followed. For the majority of showmen, the banners had to serve a purely functional purpose. Bright orange or red backgrounds were favored for their "readability" at a distance. The Coney Island banner painters also cut small, V-shaped slits into their canvases to reduce wind resistance, but when winds were too gusty, the banners were generally kept rolled up.

WITH TIME, THESE ORNATE, freak-laden showfronts became the centerpiece for many American road shows. Walter K. Sibley is credited with creating the first "ten-in-one" show in 1904, which collected a number of individual attractions into one grand sideshow. These ten-in-one shows quickly gained in popularity, and by 1910 all major carnivals featured multiple attractions that were conducted within the confines of a single large tent. Inside the tent, each act was curtained off from the next, and the showmen would introduce each performer in turn, opening and closing the appropriate curtain. For an extra quarter, customers were admitted to the "Annexe," which was touted as the most sensational or bizarre freak act of the carnival. Those freaks who did not perform often sold miniature bibles or postcards with their portraits. The larger, more successful traveling shows used more and more banners to make a splash on the midway. For the Royal American Shows, showman Cortez Lorow stacked thirty banners three tiers high to attract hordes of thrill-seekers across the country.

IN ADDITION to the Coney Island partnership of Millard and Bulsterbaum and the United States Tent and Awning Company, another major manufacturer of banners during this period was the Kansas City firm of Baker and Lockwood. Although this firm had no staff artists, they employed freelance painters, such as "Manuel," and artists working for Lutton Studios. Offshoot

enterprises drawn from the United States Tent and Awning Company were created between 1921 and 1930, during which time W. F. and Charles G. Driver opened and shut down three separate canvas painting companies. Eventually, Charles G. Driver became a partner in the O'Henry Tent and Awning Company of Chicago and took with him one of the original United States Tent and Awning Company artists, Fred G. Johnson, who had first worked for the company in 1906 at the age of fourteen.

THE SOURCES for painted canvas banners were diverse, and American showmen were not limited to the large canvas supply companies. For smaller sideshows, local sign painters and scene artists were able to meet the demands of many traveling carnivals. In Coney Island, for example, Wildman and Sons manufactured signs and banners for local showmen. Artist Bobby Wicks received his training at Wildman and Sons, eventually launching a career as one of America's leading showfront designers and banner painters.

AS AN ARTISTIC TRADITION, the sideshow banner combined the sizzle, sex, and voyeuristic aspects of vernacular art with the more sublime features of high art. In describing the banners of Chicago artist Fred Johnson, historian Dennis Adrian cites numerous influences, including the Flemish techniques of seventeenth-century Dutch painting as well as the French and Spanish Barbizon school. It is not surprising, perhaps, that in order to rise above the cacophony of the typical high-energy carnival, banners used visual pyrotechnics, shock value, and simple optical techniques to draw in their audience. Banners usually had a principal image, usually figurative in nature, that was centered in the pictorial field and surrounded by a vignette frame or flanked by curtains. As Adrian explains, this practice can be traced to the vignette-surrounds found in the images of some Japanese wood-block prints, as well as to the framing curtain that was a frequent element in

baroque portraiture. These curtains gave a sense of spectacle and pandered to the voyeuristic impulses of carnival goers. The convergence of vernacular images, popular icons, and sensationalist attractions with high art traditions gives banner painting its unique status. According to Adrian, all of these elements and formal devices have appeared repeatedly in the works of Chicago imagist painters, among them, Ed Paschke, Art Green, Phyllis Bramson, Hollis Sigler, and Roger Brown.

ARTISTS

IF THE BANNERS were sensational in their coloration and execution, the lives and talents of the artists who created them were no less so. Among the banner painters featured in this book, including Snap Wyatt, Jack Cripe, Jack Sigler, and Fred Johnson, most had long, successful careers punctuated by occasional setbacks and hard times. Of all the iconoclastic figures in the banner painting business, David C. Wyatt, better known by his sobriquet "Snap," was perhaps most influenced

by the Coney Island school. Wyatt apprenticed with John Bianchi, a scenic artist and banner painter from North Carolina, attended art classes at Cooper Union, and became a principal with the "Dragon Factory" of New York City. Here, Wyatt assisted in the creation of three-dimensional moving figures and displays for traveling exhibitions, department stores, carnivals, and world fairs. Having mastered both the art of papier-mâché and banner painting, Wyatt received steady commissions, including one for ninety banners for the Barnum & Bailey shows. The artist claimed to wear out a set of brushes on each job, and produced several banners simultaneously. In a 1980 interview with art historian Geoff Weedon, Wyatt described his innovative techniques in these terms:

First the canvas is stretched on a frame, then it is drawn in with charcoal that is affixed to the end of a long bamboo pole. When the sketch on the canvas is finished, it is laid in with the paint, all colors going to their place. I do not

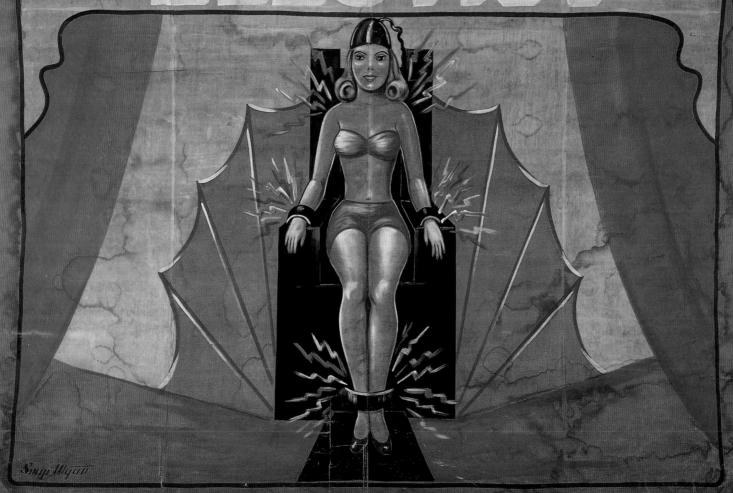

ELECTRA

Electra **SNAP WYATT** 93"x117" c.1989

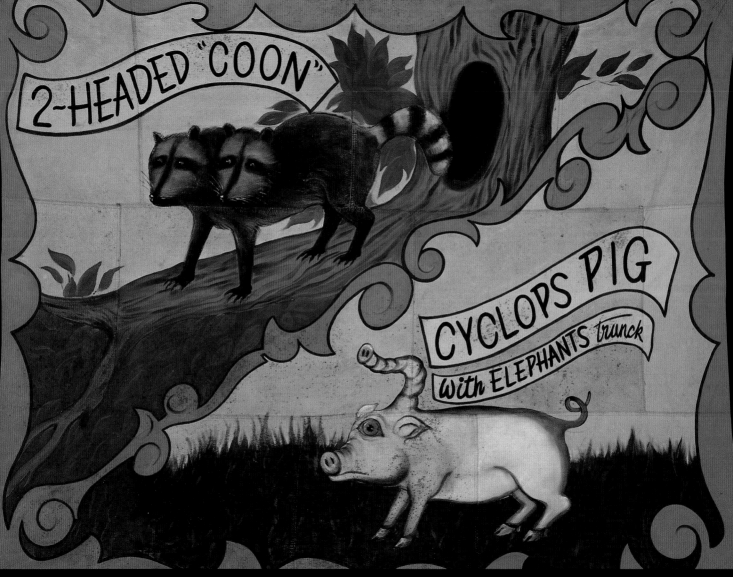

wet the canvas before painting. My formula is — oil colors containing enough water are painted on, and goes on much as whipped cream would go on canvas. When the picture is finished, it is taken off the frame, then folded so it can be lettered.

A PROLIFIC ARTIST whose works were characterized by snap and sizzle, Wyatt boasted of being able to complete a banner in as little as seven hours. Wyatt's work graced the midway at Chicago's Riverview Amusement Park, as well as many other circus sideshows. Always the innovator, Wyatt once produced a series of monochromatic banners whose black-and-white images stood out starkly from the multicolored banners that characterized sideshow advertisements.

AFTER WORLD WAR II, Wyatt moved to Tampa, Florida, a winter haven that was also a magnet for carnival showmen and banner painters. There, in 1945, Wyatt joined forces with Jack B. Sigler, a principal with the Sigler Art Service, a premier banner painting firm originating in Chicago. Within two years, Jack "Sailor" Cripe joined the firm. Cripe, a tattoo artist, had trained with Snap Wyatt and produced some of the firm's most well known banners. Cadhill, a talented painter who had lost both legs, also worked closely with Wyatt. Other important studios in the Tampa area included that of Peter Hennen, who staffed his enterprise with a number of preeminent painters, including Johnny Meah.

WITHIN THE rapidly fraying subculture of circus showmen and banner painters, Johnny Meah occupies a seminal position. Multitalented, experimental, and always pushing the envelope to outrageous extremes, Meah has been a sword swallower, musician, performance artist, sideshow impresario, writer, clown, and banner illustrator. Still residing in Riverview, Florida, Meah is perhaps the last living link to a vast storehouse of banner art and to the lost and dying trade secrets and ephemera that fueled this passionate period in American folk art. Perhaps more than any other creations of the period, Meah's paintings make a beeline to the mind, heart, and groin. He had a unique talent for elevating the grotesque to the realm of the

sublime while still maintaining respect for the humanity of the disfigured human beings put on display for their external ugliness. In his own words, Meah designed banners that would appeal to "the area that they touched" in human nature, to the senses, and to the imagination. As Meah put it, "It was a challenge to take something which is dull as dirt and make it into what it's supposed to be cracked up to be." Because the sideshow attractions were so often little more than specimens preserved in bottles, or even worse — "a dull little thing that the normal person would not give a minute's interest to," explained Meah — it was the artist's job to infuse the banner with flash, fantasy, and mystery. Consequently, having come wholly from the imagination of the artist who created them, many sideshow advertisements were fraudulent to the very core. And although the public may have been duped and deceived for many years by sideshow attractions that did not measure up to the claims of their broadsides, they were in the process treated to many wonderful examples of American art — free of charge.

AS PAINTER Johnny Meah explained, "The banners were the prettiest part of a circus sideshow." Painters rarely met more than half of the specific performers whom they were supposed to render, so they relied on previous experiences with other sideshow carnies, many of whom had "standard" medical conditions that were popular on the circuit. Much like the realist painters, banner artists became very familiar with — and, in fact, closely studied the physical characteristics of — people with birth defects, elastic skin conditions, acromegaly (gigantism), osteogenesis imperfecta (dwarfism), and other disfiguring diseases. But realistic portraiture was rarely the goal, inasmuch as painters like Meah, Johnson, and Wyatt did the best they could to exaggerate and hyperbolize the physical peculiarities of their subjects. "The paramount objective of the banners," Meah emphasized, "was to sell tickets." And consequently, the banners were usually more entertaining than the performers themselves.

WHEN IT CAME to truth in advertising on the

midway, fraudulence was the rule rather than the exception. Most of the performers, however dismal and drab they may have been in real life, were often mythologized, sanitized, aggressively advertised and in some cases, even catapulted to legendlike status on huge banners that traveled to hundreds of cities across the country. The glaring discrepancies between truth and fiction, between appearance and reality, was a big problem, Meah noted, and in large part explains why circus sideshows "were a nondelightful way of making a living."

"LET'S FACE IT, more often than not the public was disappointed," the artist admitted. "Nothing could stand up to the excitement level the banners promised, and that is why so many people who bought tickets for sideshows were very unhappy campers. I remember the banner for the Penguin Boy. Here was this black-and-white boy with perfectly proportioned wings perched atop an iceberg." To an unsuspecting audience, the banner suggested a magical encounter with a new, undiscovered creature of mythological propor-

tion. "But once they go inside," Meah recalled, "what they saw was a short man with stubby arms smoking a cigarette." The public was usually bitterly disappointed, which is why, Meah explained, "Working with a circus sideshow was like doing a comedy club from hell.... I always said if you could survive one year doing a sideshow, you could do anything."

MEAH, who painted the first of his more than two thousand banners at the age of seventeen, "came from the black-and-white world of cartooning," a world to which he was introduced by his father, a prominent cartoonist. Later, Meah was influenced by banner painter Bobby Wicks, who was a student of the great ultra-realists, and eventually, the artist fell under the spell of Willie Pogany, a nineteenth-century illustrator

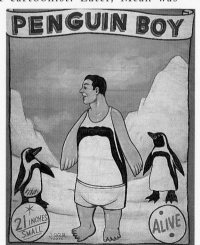

who specialized in line drawings. "We cranked out thousands of generic, stock banners during the summertime," Meah explained, "primarily for the standard 'torture' working acts... human pin cushions, sword swallowers, snake handlers, fire eaters, knife throwers, glass walkers, and the like." FOR A LONG TIME, Meah produced banners for the "stiff shows," which featured mummified creatures, babies in bottles, and other morbid, nonliving vestiges of genes gone haywire. "Eventually, though, the public became hardened to this stuff," Meah recalled, "and then we started using the bullet, 'Alive!' to draw people in. When a banner would bear the word 'Alive!' on it, the audience knew the performer was alive, or, at least, the last time you looked behind the tent he was alive."

WITH A SIXTY-FIVE-YEAR CAREER of painting images for all the great circuses — including Ringling Brothers, Barnum & Bailey, and Clyde Beatty — as well as the Chicago World's Fair of 1933, Fred G. Johnson, himself, could have been the subject of a sideshow banner. Johnson was only fourteen years old when he was discovered painting watercolors of animals in 1906 by a neighbor, who noticed him through the kitchen window. The neighbor, as it turned out, was H. C. Cummins, a banner painter for the United States Tent and Awning Company. Johnson was hired by the company in 1909, first to clean up paint pots and then to tack up banners. Eventually, he apprenticed with both Cummins and the company's principal banner painter, Nieman Eisman, who taught Johnson to work fast and use a lot of color to create "flash." During the lull in the carnival business that accompanied Word War I, Johnson took a job painting ammunition trucks for the U.S. Army. Johnson received many commissions painting banners after the war, most of them with the Driver Brothers Tent and Awning Company. With the stock market crash of 1929, the Drivers went bankrupt, and Johnson started painting banners in his own garage on the northwest side of Chicago. Although he worked solo for about five years, he was eventually persuaded by Charles Driver to join the O'Henry Tent and Awning

Company, where he worked for forty years, from 1934 to 1974. During those years, Johnson adapted his style from a more painterly approach to the freer caricature of modern banner painting. Much like other practitioners of the period, he used the traditional framing curtain surrounding a centralized image. Using white crayons, boiled linseed oil, benzene, and Dutch Boy white lead paint in paste form, Johnson perfected a technique that permitted him to work on up to five banners simultaneously. Johnson executed his paintings by tacking up canvas on a ten-foot by thirty-foot board. He sketched in the outlines with charcoal and then inked in the subjects with black paint to maintain the integrity of the outline. He then wet the canvas and applied a thin coat of white lead paint on top of water, linseed oil, and benzene. With the canvas primed in this manner, he applied the background and figures, and let them dry. The next day, he added the finishing touches. He never used varnish because he feared that the canvases might stiffen and crack. Like other artists working from 1900 to 1920,

Johnson favored light chrome yellow, orange, bright red, burnt sienna, burnt umber, ultramarine, Prussian blue, and light chrome green.

DURING THE early part of his career, Johnson painted banners that featured magicians, sword swallowers, snake charmers, and fire eaters. Over time, however, his subject matter became more bizarre, featuring sensationalized oddities and other casualties of human nature. Like Meah, Johnson recognized that his artistic skills were sometimes used to make fraudulent claims, a phenomenon his grandson, Randy J. Johnson, recalled this way:

> It was his job to create, using the banner as his medium, a glamorous and mystical illusion for the sideshow acts, which is what the sideshows were all about. The commissions came in different forms. Sometimes promoters would give him ideas of attractions, and he would create a fantasy character on canvas. For example, a sideshow would need a banner of "a boy with feathers instead of hair," and grandpa

Fred would paint a banner without ever seeing a boy with feathers on his head. Other commissions were for actual, living circus and sideshow performers. Sometimes he painted them from memory, while other times a photograph was used as a reference.

PeRfOrMeRs

ALTHOUGH THE extraordinary pictorial richness of sideshow banners often exaggerated or sanitized the subject matter, it is important to remember that courageous human beings were at the center of the circus sideshow. Behind the banners that advertised the Double-Bodied Girl, the Mother Who Shocked the World, the Rubber-Skinned Girl, Popeye, Fifi, the Woman Changing to Stone, and the Two-Faced Man, were living, breathing human beings, many of whom were victims of acquired diseases or genetic abnormalities. As banner painter Johnny Meah put it, "I love this business like it was a person."

And from all accounts, there were many people to be loved. The strength, willpower, and resourcefulness required by people with grotesque physical defects to capitalize on their aberrations can only be fully understood by those who have endured them. The vast majority of sword swallowers, illusionists, and human oddities who have worked America's more than five hundred traveling carnivals gather each winter in Gibsonton, Florida. Here, among the trailer parks and cinder-block houses, once gathered the eight-foot, four-inch Al Tomaini and his wife, Jeannie; the 602-pound Happy Dot Blackhall; Sealo the Seal Man; and Bobby Jean Taylor, the Dog-Faced Girl. Advances in medical science and waning audience interest have meant the decline of freak shows. Inevitably perhaps, the circus sideshow banners featured in this book have become the most durable reminders not only of the artists who created them but of the rich, diverse collection of human beings who gave this work its inspiration.

TOAD MAN with

"I love this business like it was a person."
-Johnny Meah

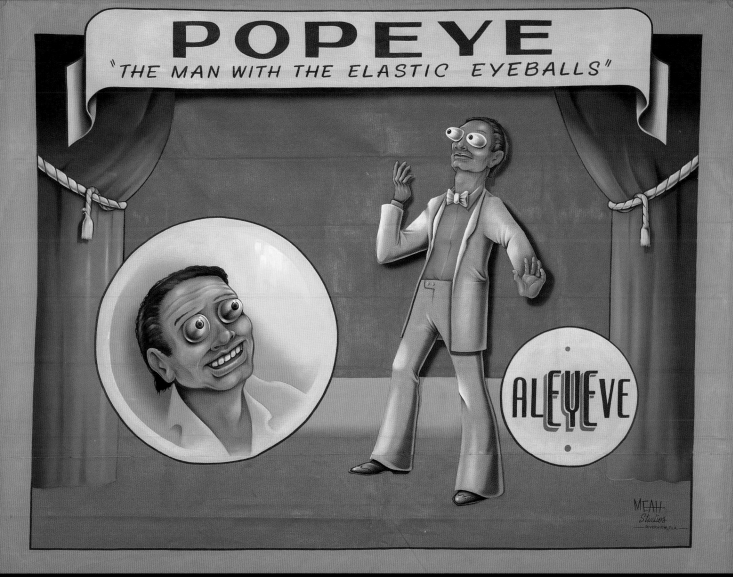

THE GROTESQUELY GIFTED

IN THE VERY LAIR OF CARNIVAL PLEASURES, AMONG THE CEASELESS CHATTER OF HAWKERS PITCHING CHEAP TRICKS AND THE SMELL OF HOT MOLASSES AND POPCORN, THE ODDLY GIFTED PERFORMED GROTESQUE TRICKS — MOST OF THEM ILLUSIONS — FOR A CURIOUS PUBLIC. WHILE MANY OF THESE STRANGELY TALENTED PERFORMERS SUFFERED FROM UNUSUAL MEDICAL DISORDERS THAT PERMITTED THEM TO ENGAGE IN BIZARRE CONTORTIONS, OTHERS WERE GARDEN VARIETY ILLUSIONISTS WHO RELIED ON

tricks and props to give the appearance of performing grotesque acts. Popeye, who suffered from the eye-bulging medical disorder called Grave's disease, startled audiences with his "elastic eyeballs," while the Iron-Tongued Marvel suspended a twenty-five-pound anvil from his tongue with a chain. The Marvel employed an oral prosthetic device to which a hook was attached — the prop was inserted into his mouth out of the audience's view — in order to accomplish his dramatic tongue lifts. The Marvel's weight-suspending feat was a variation on the performance that was popularized by Rasmus Nelson, a showman who claimed to have been captured, tattooed, and tortured in the South Sea islands. According to Nelson, who performed widely in the 1930s, his "savage" captors had also implanted rings into the skin of his chest and then suspended him from trees as part of his incarceration. Capitalizing on this experience, part of Nelson's show included lifting an anvil by the torture rings that were still lodged in his chest. Afflicted with a collagen disorder known as Ehlers-Danlos syndrome, the Rubber-Skinned Girl could stretch her skin as much as one foot from almost any part of her body.

SWORD SWALLOWERS and ingestors were among the most revered "working" acts a carnival could feature on its midway. "The Great Waldo," a talented ingestor from Germany who performed during the 1930s, could gobble objects of unusual size, including lemons and mangos, which he then regurgitated upon command. The highlight of his act was swallowing a live mouse and then bringing it back up at the request of an audience member. The first sword swallower in the United States, Sena Sama, delighted audiences by taking two-foot-long swords and plunging them deep into his gullet. When it comes to sword swallowing, explained Johnny Meah, virtuoso banner painter and sword swallower, it's simply a question of "mind over matter." There are occasional slip-ups, however, like the time Meah ate fried chicken before a show — the sword slid through his greasy fingers, down his gullet, and hit his breastbone with a bruising clank. Fortunately, except for a minor injury, the performer recovered without complications.

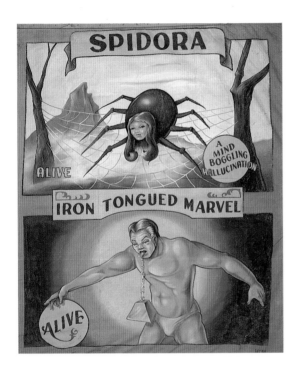

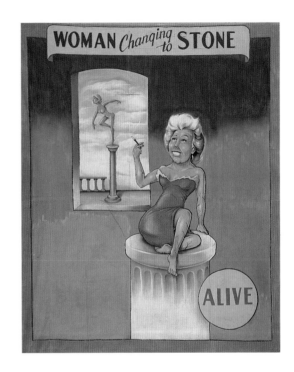

JoHnNy MeAh

SPIDORA/IRON TONGUE

132" x 109" c. 1960-70

JoHnNy MeAh

WOMAN CHANGING

TO STONE

149" x 119" c. 1989-90

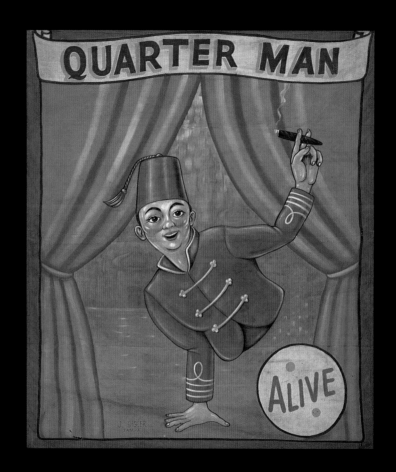

QUARTER MAN
139"x115" c.1979
COLLECTION OF HENRY
LANDAN

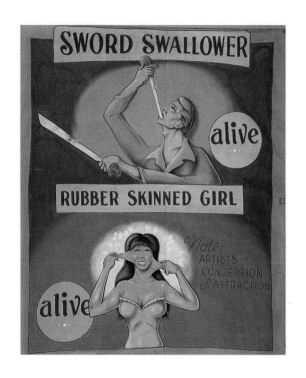

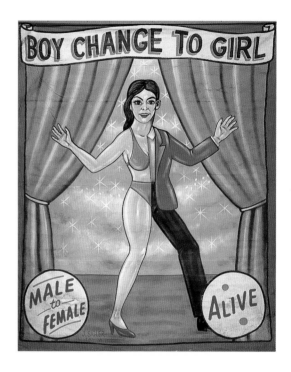

JoHnNy MeAh

SWORD SWALLOWER/
RUBBER SKINNED GIRL
142"x118" c.1960s
COLLECTION OF TEM HOROWITZ

JoHnNy MeAh

BOY CHANGE TO GIRL
120"x96" c.1989

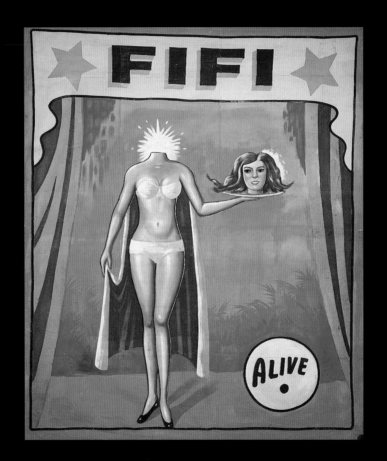

FIFI
138"x118" c.1950-60

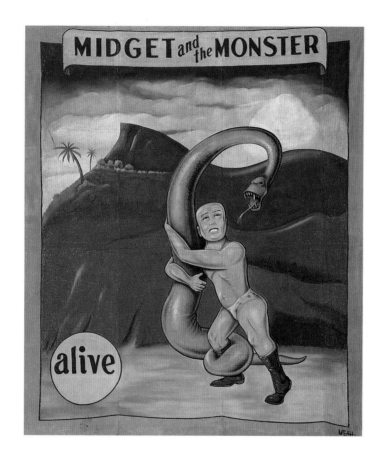

MIDGET AND THE MONSTER
157-1/2" x 125-1/2" c. 1960-70
COLLECTION OF TEM HOROWITZ

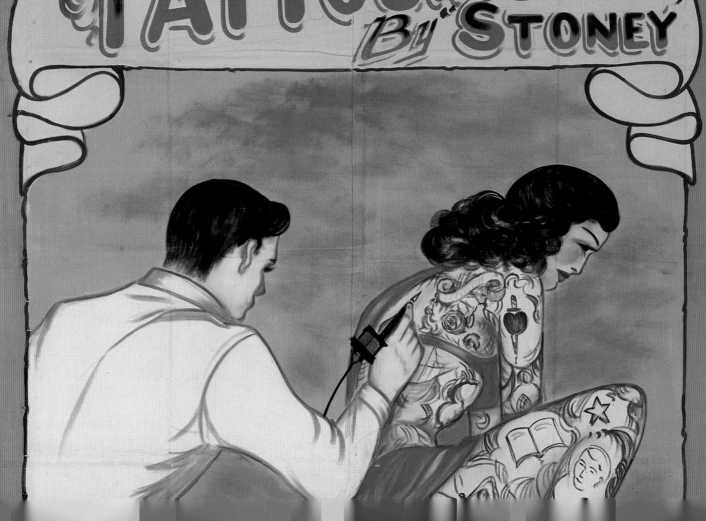

PAINTED LADIES AND TATTOOED MEN

ALTHOUGH THEIR TALENTS MAY HAVE BEEN ONLY SKIN DEEP, TATTOOED MEN AND WOMEN WERE AMONG THE PREMIERE ATTRACTIONS ADVERTISED ON PAINTED BANNERS THAT PEPPERED THE CARNIVAL MIDWAY. THAT THE CIRCUS—GOING PUBLIC WAS FASCINATED WITH BODY DECORATION WAS FIRST NOTICED BY SEAMEN, WHO AFTER EXTENSIVE BODY TATTOOING BY SOUTH PACIFIC NATIVES, DISCOVERED THAT PEOPLE IN AMERICA WOULD ACTUALLY PAY TO VIEW THEM. WITH INCREASING

competition in the world of tattooed showmen came exaggerated stories about the origins of this body decoration. John Rutherford, for example, was a mariner who returned from New Zealand with tattoos covering most of his body. According to legend, he was captured by South Pacific natives, who held him prisoner for six years and compelled him to marry the chief's daughter. He had three children and was forcibly tattooed. Variations on this storyline were copied, amplified, and exploited by others. Among the most popular was the Great Omi, also known as the Zebra Man, who had broad black and blue zebra stripes tattooed over his entire body; the process took more than five hundred sittings to complete. The appeal of tattooed performers, such as Wilson, the Tattooed Man who made the circuit in Coney Island, lies in their ability to withstand pain and bizarre acts of self-mutilation. The tattooed performer appeared as one who had defied pain, not in one great gesture (like a nail in the nose) but in a thousand tiny acts of bodily violation.

ALTHOUGH TATTOOED exhibitionists were once paid substantially, by the early 1900s interest in this form of sideshow declined. Because there was an overabundance of tattooed men and women, the competition became extreme, and sometimes bordered on the outrageous. Suddenly, whole families of tattooed people appeared behind the sideshow curtain, a fad that was followed by tattooed dogs, cows, midgets, and fat ladies. Eventually, being tattooed was not enough, and as a result, performers imprinted with the stigmata of exotic cultures expanded their appeal by taking up sword swallowing and knife throwing.

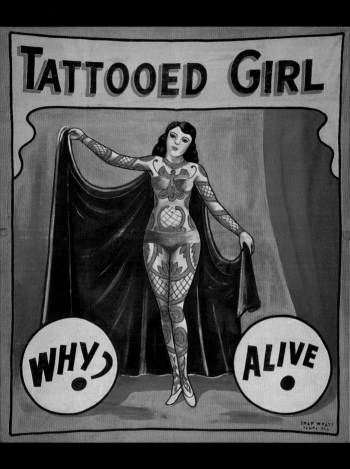

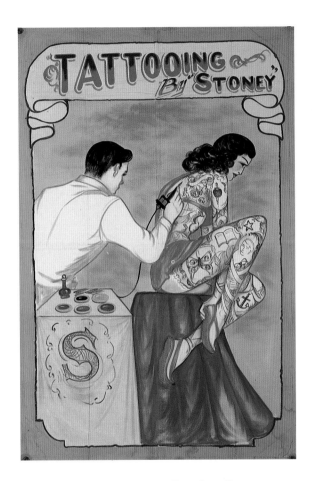

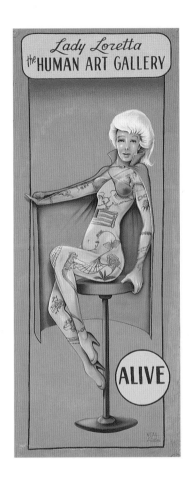

F R E D J O H N S O N

T A T T O O I N G B Y S T O N E Y
9 6 " x 6 2 " c . 1 9 3 0 - 4 0
C O L L E C T I O N O F L A R R Y
A R O N S O N

J O H N N Y M E A H

L A D Y L O R E T T A
T H E H U M A N A R T G A L L E R Y
1 1 6 " x 4 6 - 1 / 2 " c . 1 9 8 9

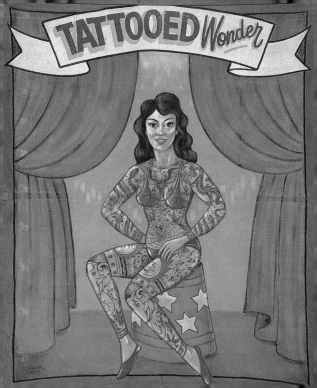

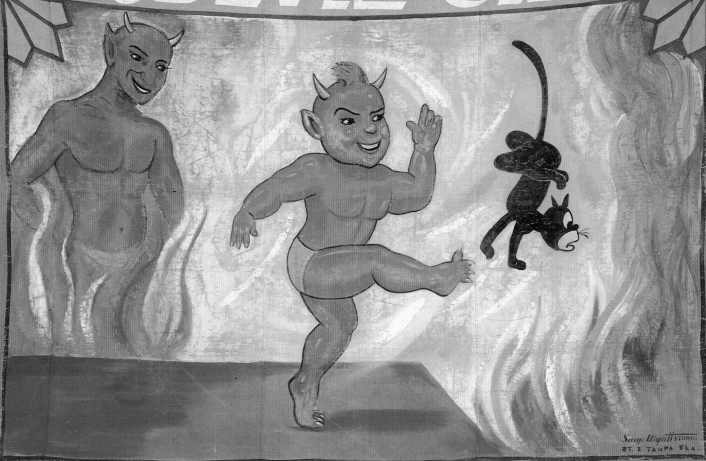

The DEVIL CHILD

THE STRANGE AND DERANGED

THESE MACABRE BANNERS HAD A SPINE-CHILLING APPEAL THAT SPOKE TO THE DARKER SIDE OF THE HUMAN PSYCHE. A MORBID INTEREST IN ATROCITY, PHYSICAL FREAKINESS, AND VIOLENT DEATH SOLD THESE SIDESHOWS. IN MANY CASES, THE CRIES AND GROANS OF VICTIMS WERE PRERECORDED, AND THE FIGURES WERE MECHANIZED AND POWERED WITH ELECTRICITY. "JOURNEY INTO FEAR," "TORTURE CHAMBER," AND "CHAMBER OF HORRORS" WERE SOME OF THE MORE ALLURING

sideshow titles. Banners such as "The Garrotte" featured exercises in strangling, while other sideshows, such as "Demon Creatures," depicted exhumations of human grave sites. The majority of these performances were merely play-acted and consisted of grossly inaccurate recreations of stories passed down from the Spanish Inquisition.

When not play-acted, human figures fashioned from papier-mâché or fiberglass underwent simulated torture. These performances were presented against the backdrop of continuous audio loop tapes that shocked the audience with high-pitched shrieks and cries of horror.

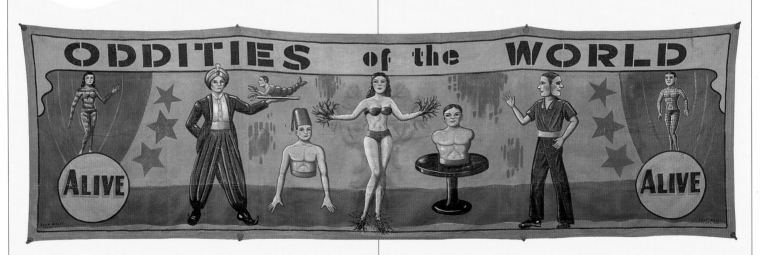

SNAP WYATT

ODDITIES OF THE WORLD
100"x354" c.1940s

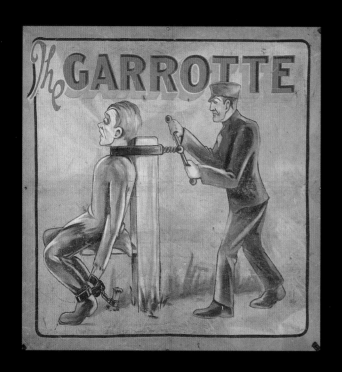

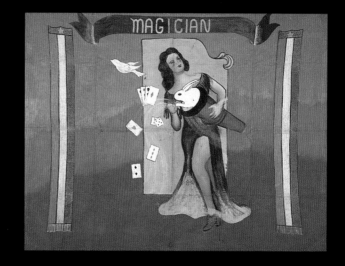

THE GARROTTE
70"x68" c.1940s
COLLECTION OF
M. LA GUARDIA

MAGICIAN
89"x110" c.1920-30
COLLECTION OF
M. LA GUARDIA

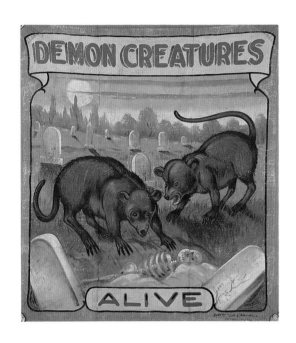

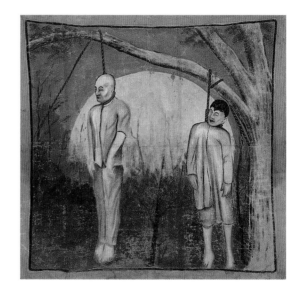

F r E d J o H n S o N

D E M O N C R E A T U R E S
9 1 - 1 / 2 " x 8 2 - 1 / 2 " c . 1 9 5 0 s
C O L L E C T I O N O F
R I C K S M I T H

A n O n Y m O u S

U N T I T L E D
6 9 " x 7 0 " c . 1 9 4 0 s
C O L L E C T I O N O F
M . L A G U A R D I A

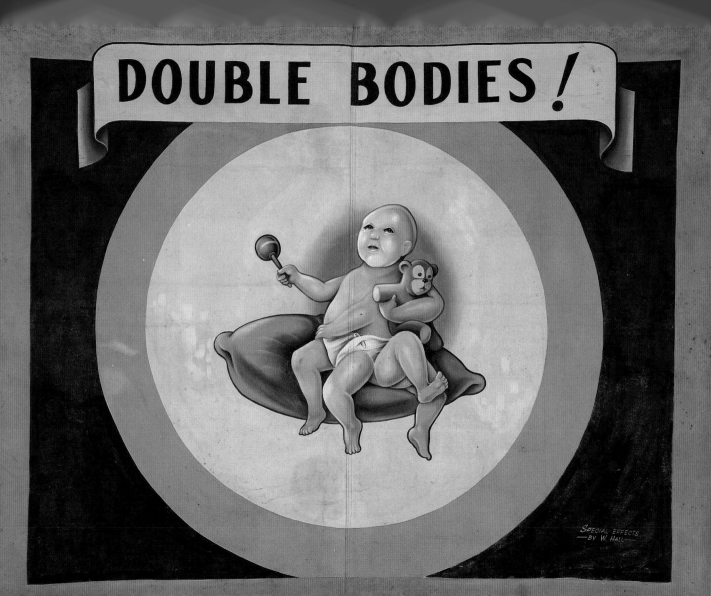

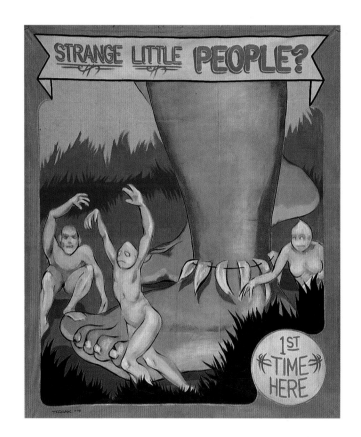

STRANGE LITTLE PEOPLE?

116" x 94" c. 1960s

A DEVIL'S DAUGHTER
140" x 119" c. 1950s

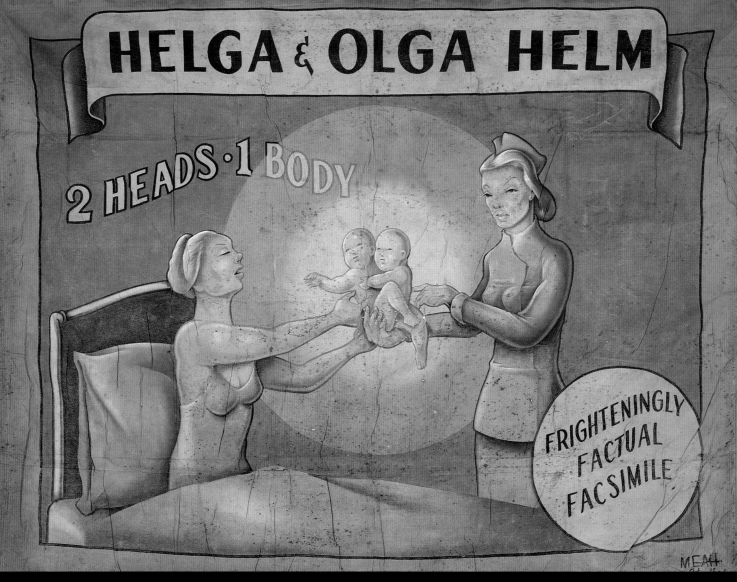

HELGA & OLGA HELM

2 HEADS · 1 BODY

FRIGHTENINGLY FACTUAL FACSIMILE

Helga and Olga Helm JoHnNy MeAh 80"x109" c. 1960s

FrEaKs Of NaTuRe

NO CIRCUS SIDESHOW WAS COMPLETE WITHOUT ITS SO–CALLED "FREAKS OF NATURE," EXAMPLES OF THOSE ODDITIES AND MISFORTUNES THAT AFFLICT HUMANITY IN THE WOMB. THESE WERE PERENNIAL ATTRACTIONS THAT ELICITED BOTH HORROR AND COMPASSION, AND IT WAS SAID BY SHOWMEN OF THE PERIOD THAT BUSINESS ALWAYS SEEMED TO INCREASE WHEN DEPICTIONS OF FREAK ACTS INCLUDED SEXUAL OVERTONES. MANY OF THESE PAINTINGS, SUCH AS THOSE OF HELGA

and Olga Helm, exploited the horrifying effects of thalidomide, a sedative that causes malformations in the fetus when taken during pregnancy. As late as 1947, Coney Island displayed premature babies in incubators.

SIAMESE TWINS, two-bodied people, and double-faced men were among the most monstrous of all attractions. Especially in the case of Siamese twins, forgeries and fakes were much more common than the real McCoy. One of the most celebrated frauds in the world of anatomically linked humans was a pair of beautiful Mexican Siamese twins who fell into a heated argument during the middle of a performance in 1953. So acrimonious was their altercation that they separated in full view of their audience and left the stage in a huff. As the story goes, the only person who was more shocked than the onlookers was the owner of the show, who himself believed that the girls were authentic. He later said, "Those girls were tied together with some sort of corset.... I guess I wasn't the first man to be fooled by a corset." Adolph and Rudolph were another famous Siamese twin fraud that managed to fool the public for many years. These two men, who had obviously dissimilar facial features, pulled off a hoax that was nothing less than miraculous, considering the fact that joined twins are always identical, no matter where their anatomic connection may be.

NOT SURPRISINGLY, forgeries were not limited to Siamese twins. Pasqual Pinon was a two–headed Mexican who featured a smaller head protruding from the top of his forehead. The upper head lacked facial animation and featured eyes, a mouth, and a nose that were not fully developed. As Mr. Pinon entered the performing arena, the audience was told that he had been able to see, smell, hear, and talk with the upper head until he turned twenty, at which time the upper head had atrophied permanently. This so–called "Two–Headed Creature" was finally exposed as a fake when it was discovered that his second head was really a benign tumor that was outfitted with facial features. Other genetic anomalies included the Lobster Man, who had hands that were split down the middle, and the Penguin Boy, who had poorly formed arms and legs.

NO CIRCUS SIDESHOW was complete without the so–called "Missing Link," a person who was adver-

tised as part human and part beast. Persila, the Monkey Girl, was simply a woman who had thick hair on her face and hands, whereas "The Blue Man" consumed silver nitrate to turn his skin a strange hue of blue. William Henry Johnson, known as "Zip," or "The Monkey Man," was a Coney Island phenomenon between 1860 and 1926. This very short man had a large nose connected to the top of his head, giving the appearance of having no forehead. He appeared on the stage dressed in a gorilla suit, and was touted as the missing link between man and animal. For years, Zip was the highest–paid freak at Coney Island, and would jump up and down in a cage and scream in his hairy suit. These aberrations may have appeared monstrous, but as the famous Bearded Lady, "Lady Olga" (who had a normal imbalance that produced excessive facial hair), once commented after being asked about the gawking crowds: "If the truth was known, we are all freaks together."

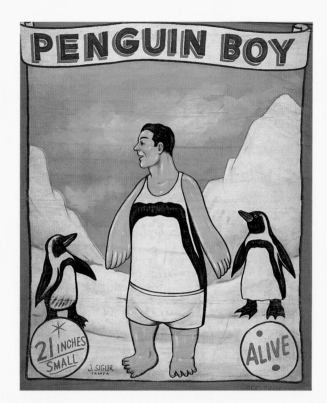

JACK CRIPE

PENGUIN BOY
137-1/2" x 114" c. 1960s
COLLECTION OF
TEM HOROWITZ

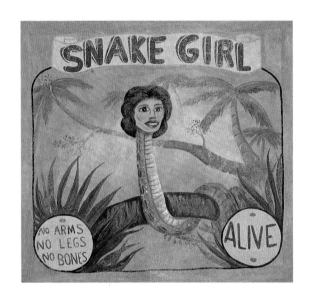

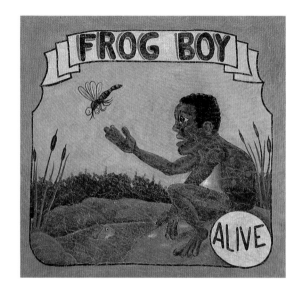

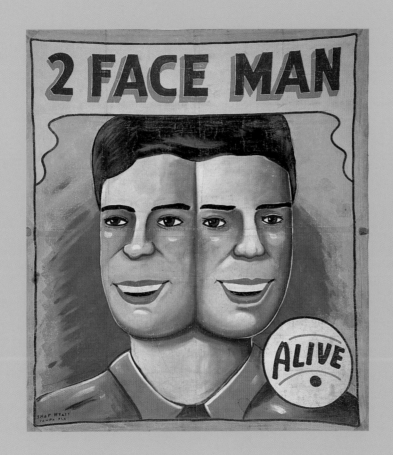

2 FACE MAN

136"x118" c.1930s

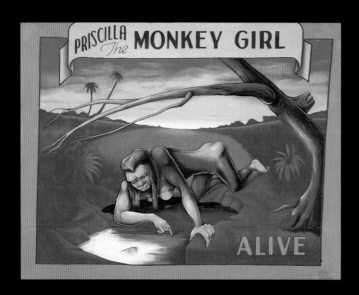

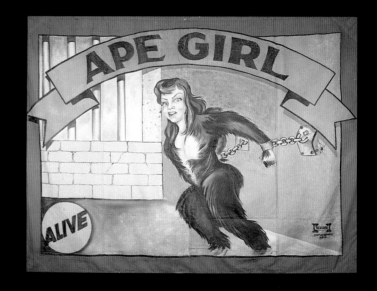

PRISCILLA THE MONKEY
GIRL
93"x117" c.1990s
COLLECTION OF
JERRY ABRAHAMSON

APE GIRL
89"x118" c.1960s
COLLECTION OF
PHILIP CANTRELL

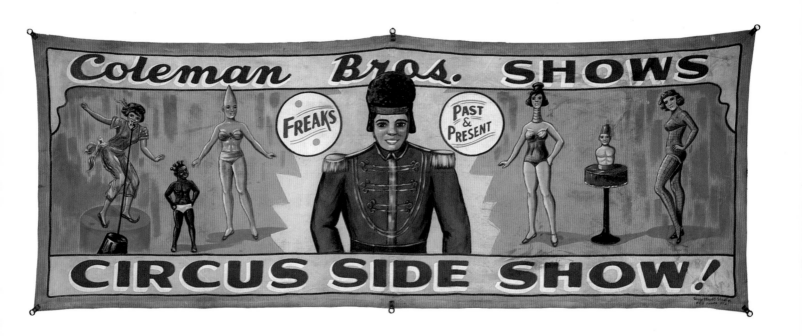

COLEMAN BROS. SHOWS

96" x 240" c.1940s

COLLECTION OF DEAN

JENSEN GALLERY

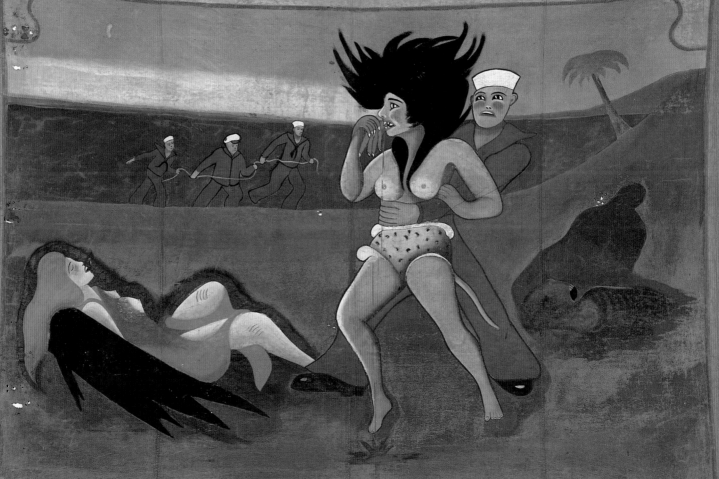

THE LEGENDARY EEKA

MANY ARTISTS, INCLUDING AL RENTON, SNAP WYATT, AND FRED JOHNSON, CREATED BANNERS FEATURING THE AMAZING EEKA, "A WILD CREATURE FROM THE JUNGLE WHO IS CONFINED TO A PEN FOR THE VIEWER'S ABSOLUTE PROTECTION." A SERIES OF BANNERS, AMONG THEM "EEKA AS SHE IS TODAY," "EEKA'S NATIVE HAUNTS," "EEKA CAPTURED," AND "EEKA AND THE SNAKES," FED AMERICA'S CURIOSITY AND INTRIGUE WITH THE SOUTH PACIFIC ISLAND OF FIJI, WHICH WAS

associated with cannibalism. Although American explorers had reported only one incident of cannibalism on the island itself, carnival goers nevertheless had the impression that human flesh was an important staple in each islander's diet. This folklore had its roots in the tales of British Royal Navy Captain James Cook, who in the late 1700s charted the South Sea islands and reported that a boatload of his men had been killed and eaten in New Zealand. These tales filtered back to America, and carnival showmen capitalized on them by displaying "natives" as captured cannibals. Eeka, as it turned out, was no cannibal, but merely a South Pacific islander, which was enough during this relatively xenophobic period in American culture to make her a human oddity, a freak, a "living specimen from a primitive culture." Carnival showmen shamelessly capitalized on her ethnic differences and embellished these folk-tales with elaborate stories of a pseudoanthropological nature.

AL RENTON

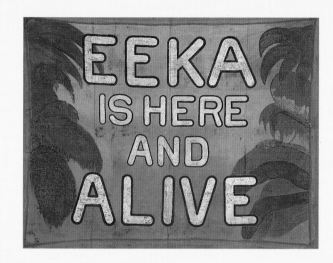

EEKA IS HERE AND ALIVE
91"x114" c.1940-50

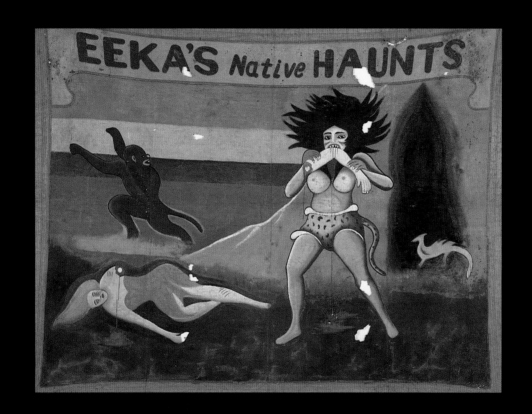

EEKA'S NATIVE
HAUNTS
93"x117" c.1940-50

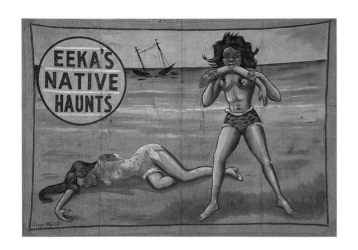

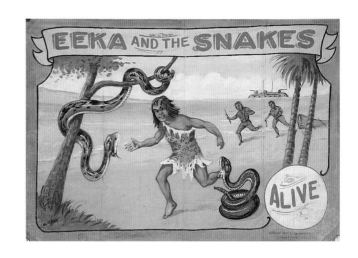

SNAP WYATT

EEKA'S NATIVE
HAUNTS

77" x 112" c.1950s

FRED JOHNSON

EEKA AND THE
SNAKES

83" x 115" c.1950-60

COLLECTION OF

MICHAEL STIPE

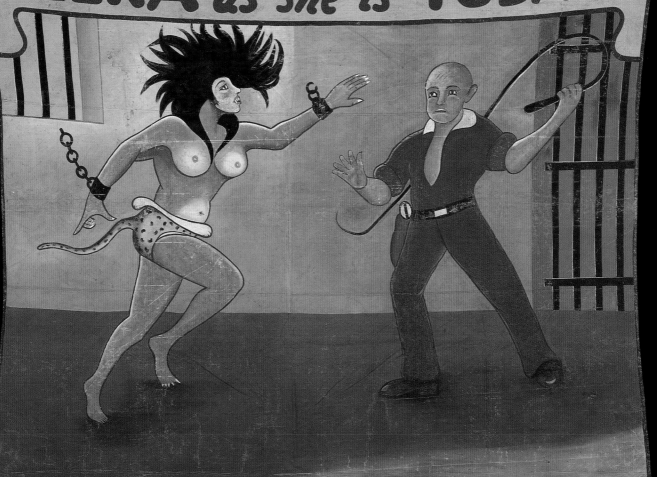

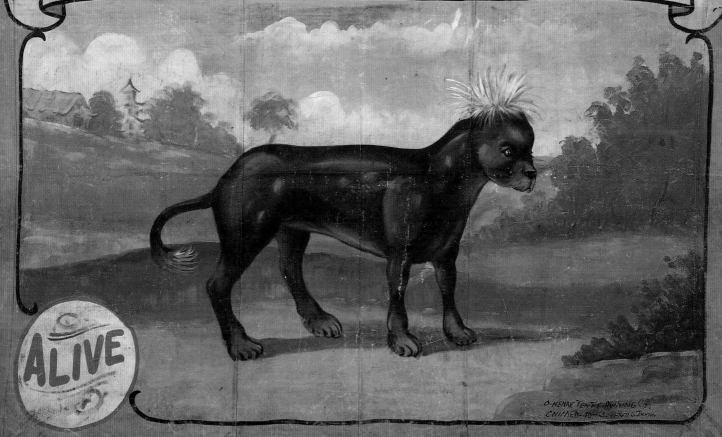

Chinese Hairless Dog **FrEd JoHnSoN** *68"x95" c. 1940–50s Collection of Dale Chihuly*

OdDiTiEs Of tHE aNiMaL wOrLd

TO A GREAT EXTENT, TRAVELING SIDE-
SHOWS WERE AS DANGEROUS, DIRTY, DEGENERATE,
AND EXCITING AS DISNEYLAND IS SAFE, CLEAN
WHOLESOME, AND BLAND. DISRUPTING THE
HO-HUM RHYTHMS OF DAILY LIFE, THESE CIRCUSES
OFFERED AN EXPLOSION OF MADCAP AMUSEMENTS,
MANY OF WHICH TRANSFORMED DEFORMITIES INTO A KIND OF
CELEBRITY. THE BANNERS WERE PURPOSELY LARGE IN SCALE
AND FEATURED INTENSE COLORATION, SO THAT THEY COULD BE

seen from long distances, especially in more remote rural areas. Given the familiarity that farmers and other countryfolk had with animal breeding – as well as with the domestication of cows, dogs, and fowl – banners featuring oddities of the animal world exerted an inexhaustible attraction.

MIDGET COWS, four-legged ducks, Chinese hairless dogs, and midget bulls were artificially concocted by taxidermists to create preposterous aberrations of Mother Nature, which served as a counterpoint to the perfectly bred animals and livestock raised on country farms. There was no limit to the manipulations of animal anatomy; everything was fair game with these pseudoscientific fabrications. Wigs, unusual haircuts, hair dyes, and other bizarre cosmetic treatments were combined to create midget horses, giant king crabs, and raccoonlike creatures that were advertised as being "one-half bear, one-half monkey." The fraudulence of these advertisements reached a preposterous extreme in the case of Sally, the "Non-Human Oddity." "Sally was born in a barn in 1962, and she never had a normal life," was the

lead statement by P. L. Bradshaw, who hoped to convince his sideshow audience that there was a live monstrosity on display. Assuring everyone that this was a family show, Bradshaw pulled Sally out of a small trunk. As it turned out, Sally was nothing more than "a pickled pig" who was born with several extra legs and preserved in formaldehyde.

F R E D J O H N S O N

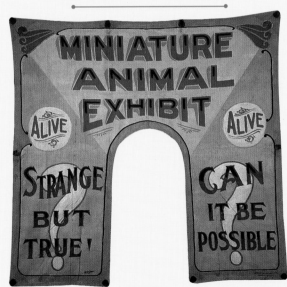

EXHIBIT ENTRANCE BANNER
1 4 1 " x 1 3 4 " c . 1 9 5 0 s

FrEd JoHnSoN
MIDGET TRILOGY

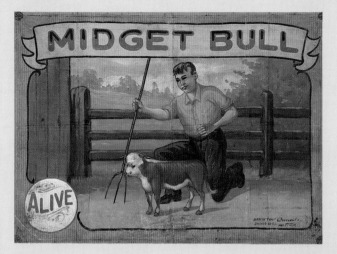

68"x95" c.1960s
COLLECTION OF
RICK BAYLESS

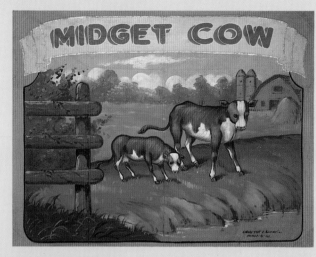

92"x115" c.1950s
COLLECTION OF
MICHELLE KNAUSS

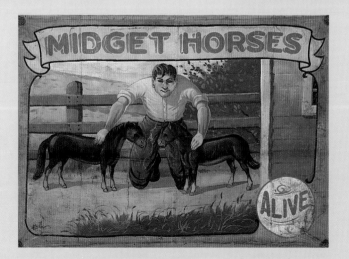

68"x95" c.1950s

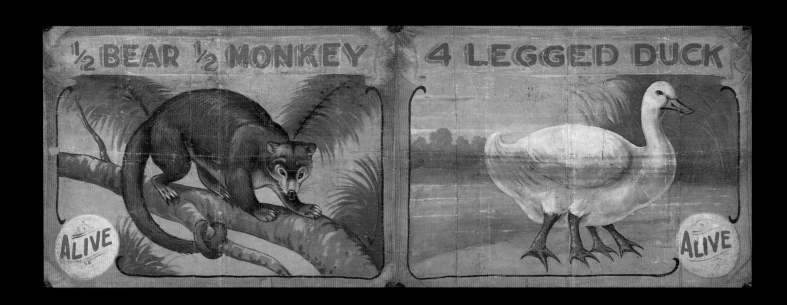

1/2 BEAR 1/2 MONKEY
Side B
4-LEGGED DUCK
68"x95" c.1950s

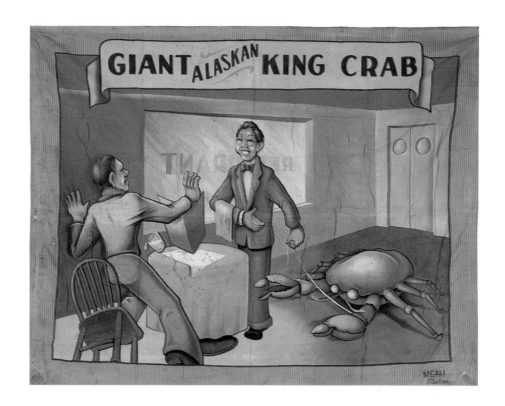

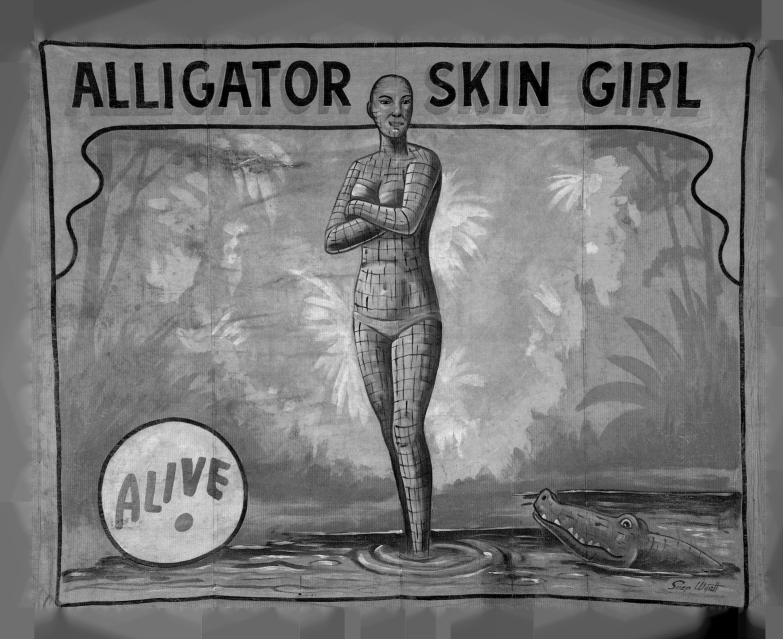

MyThIcAl MoNsTrOsItIeS

ONE OF THE MOST CURIOUS AND UNUSUAL TALENTS OF BANNER PAINTERS WAS THE ABILITY TO SANITIZE — SOMETIMES EVEN MYTHOLOGIZE — FLAGRANT EXAMPLES OF HUMAN MISFORTUNE WHILE AT THE SAME TIME SATISFYING THE VOYEURISTIC IMPULSES OF THE CARNIVAL—GOING PUBLIC. IN THE CASE OF MOST BANNERS, ARTISTS SUCH AS SNAP WYATT AND JOHNNY MEAH WERE ABLE TO PRESENT GROTESQUE HUMAN DEFORMITIES AND PHYSICAL ACTS WHILE MAINTAINING COMPASSION

for their subjects. Although "Knotty, the World's Ugliest Man," "The Spotted Girl," and "Alligator Girl" were clearly afflicted with incurable and disfiguring dermatological disorders, the artists humanized these subjects by presenting them with rather positive, almost upbeat facial expressions. The affection and respect that modern banner painters had for their living subjects was nowhere in evidence during the late nineteenth century, when "museums of anatomy" traveled from city to city, capitalizing on the obsessive interest that proper Victorians had in sensationalism and "improper matters." Touted by their impresarios as a social service of sorts, these museums of anatomy featured a hanging canvas depicting surgical operations and patients with terminal diseases. Collections of preserved organs, skeletal remains, bizarre photographs of human deformity, and skillfully formed waxworks were displayed beneath the backdrop for public scrutiny.

FORTUNATELY, by the 1940s, modern medicine had found cures for many of the skin diseases, disfiguring defects, impairments in growth and stature, and hormonal imbalances that produced among other things, protruding jaws and gigantic hands. Then, as it became more difficult to find so-called "authentic freaks," show owners relied more on fakes to entice their voyeuristic public. However, gawking at people with disfiguring diseases and other misfortunes became socially unacceptable by the mid-1950s. Though out of "work," many of these carnies not only survived, but went on to live lives filled with love and courage.

EMMITT BEJANO, also known as the Alligator Man, suffered from a dry, scaly skin condition known as ichthyosis. He met Priscilla Lauther, the Monkey Girl, who was born with a condition known as hirsutism, a hormonal imbalance that produced a full body coat of silky black hair. They fell madly in love, but Priscilla's foster father contained their passion, and their relationship was confined to smuggled letters until 1938. That year, Priscilla eloped with Bejano, a union that was advertised with the following headline: "Monkey Girl kidnapped by Alligator Man."

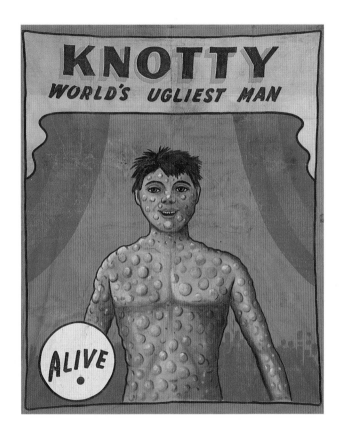

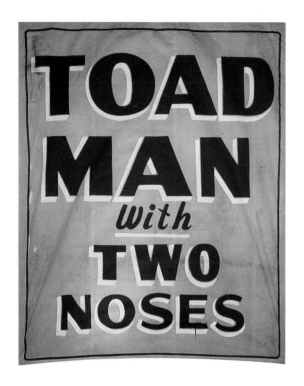

SNAP WYATT

TOAD MAN WITH
TWO NOSES

244-1/2" x 102" c.1950s

SNAP WYATT

LOBSTER BOY

248-1/2" x 104"

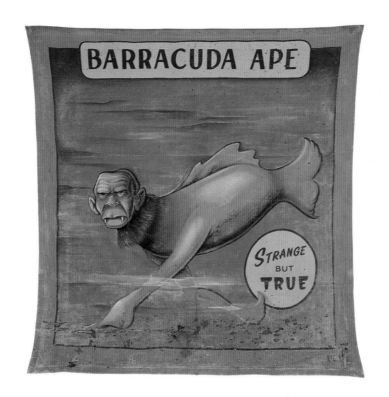

BARRACUDA APE
93"x87" c.1960s

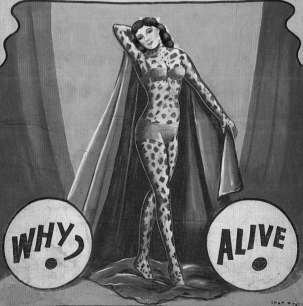

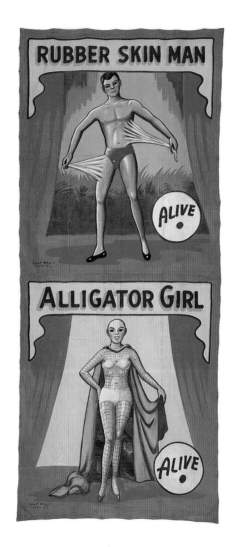

RUBBER SKIN MAN/
ALLIGATOR GIRL
246"x104" c.1950s
COLLECTION OF KARL
WIRSUM AND LORI GUNN

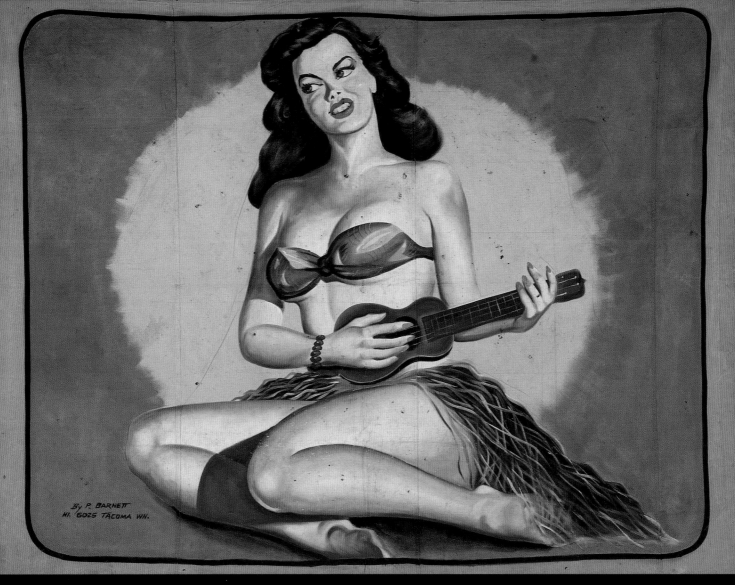

By P. BARNETT
HI. 6025 TACOMA WN.

"untitled" **P BARNETT** 92"x115" c.1940-50s Collection of M. La Guardia

THE eXoTiC aNd ErOtiC

TITILLATION AND SEX WERE COMMON INGREDIENTS AT NINETEENTH-CENTURY FAIRS, WHICH ACTUALLY PROVIDED PROSTITUTES WITH AN OPPORTUNITY TO FIND NEW CLIENTS. IN FACT, VICTORIAN MORALISTS CONSIDERED TRAVELING SIDESHOWS TO BE A CORRUPTING INFLUENCE. FOR THE MOST PART, PAINTED BANNERS REPRODUCED PIN-UPS MUCH AS THEY APPEARED IN SO-CALLED "GIRLIE MAGAZINES." DURING THE 1940s, MANY BANNERS INTENTIONALLY BROADCASTED MISLEADING

erotic overtones. They used sexually explicit images to lure the public into shows that preached the dangers of sexually transmitted diseases. Some performers, such as Mona, the Snake Girl, were featured with reptiles that coiled around naked bodies. One of the most famous Coney Island sideshow entertainers, "Little Egypt," was Fahreda Mahzar, who began her performing career at the World's Columbian Exposition in 1893. She spent the next several years wriggling, shaking, and sliding on her belly like a snake in "the streets of Cairo," at Coney Island, until the crowds eventually became bored. She left the stage to lead a "normal" life as a wife and mother.

S N A P W Y A T T

CLEO MOON GIRL
138" x 119" c.1950s

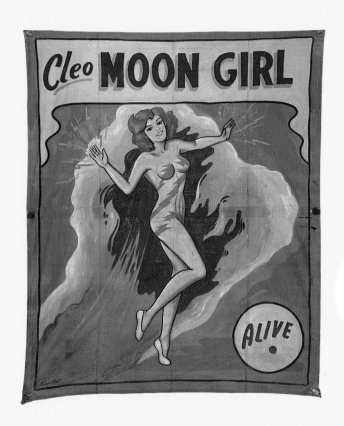

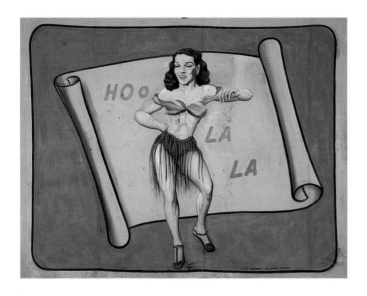

HOO-LA-LA

92" x 113" c.1940s

COLLECTION OF

M. LA GUARDIA

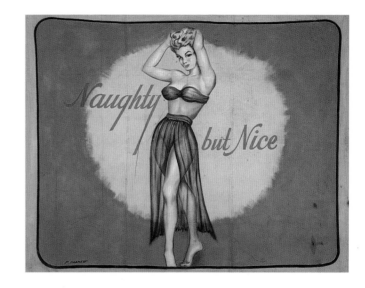

NAUGHTY BUT NICE

88" x 114" c.1940s

COLLECTION OF

M. LA GUARDIA

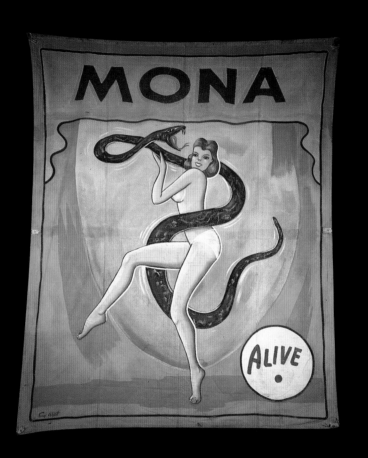

SNAP WYATT

MONA

138"x118" c.1950-60

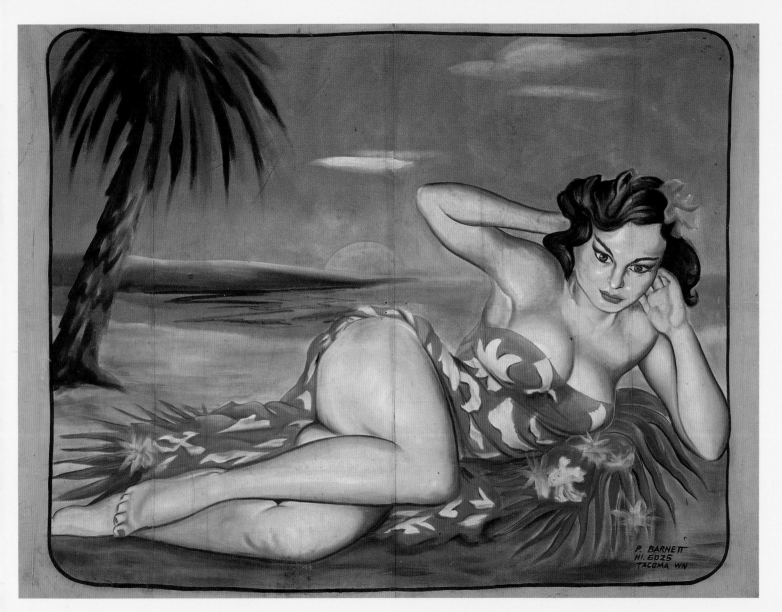

"untitled" **P BARNETT** *93"x112" c.1940s Collection of M. La Guardia*

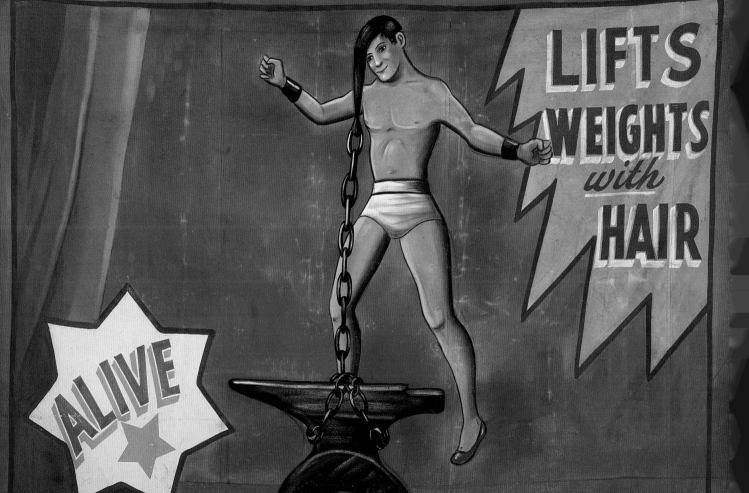

DANGEROUS LIAISONS

THE HUMAN BLOCKHEAD IS THE GENERIC SIDESHOW NAME FOR A PERFORMER WHO HAMMERS NAILS, SPIKES, AND ICE PICKS UP HIS NOSE AND INTO HIS SINUSES. LIKE ALL "DANGEROUS ACTS" IN THE SIDESHOW, THE EFFECTIVENESS OF THIS PER-FORMANCE DEPENDS ON THE SPECTATORS' DISCOMFORT WITH THE VIOLATION OF THE BODY BY FOREIGN OBJECTS. THIS ACT WAS CONCEIVED AND DEVELOPED BY MELVIN BURKHART, WHO, AFTER HIS NOSE WAS SQUASHED IN THE BOXING RING — AND THEN REQUIRED

the removal of twenty-two bone fragments — became a hospitable recipient to spikes and nails up his nasal passage. Burkhart also performed as Rubber-Necked Man, Neck Stretch, Man Without a Stomach, and Two-Faced Man, in which he screwed half his face into a frown and half into a smile. Burkhart was an anatomical wonder who performed in Bradshaw's Circus of World Curiosities in Coney Island. These acts were known as "anatomical routines." In the case of the Rubber-Necked Man, he would contort his tendon and neck muscles in order to create a gigantic bulge, giving the illusion that his neck was being stretched beyond normal limits. In the Man Without a Stomach act, Burkhart would draw his stomach in under his rib cage, and then expel it, giving the appearance that he could voluntarily control the movements of his internal organs. A natural comic, he always insisted that it only looked like he was hammering spikes up his nose. During his act, he would slide ice picks into his nasal sinus, while commenting, "Feels good once it quits hurtin'." He was also known for pounding four-inch metal spikes into his nose with loud clanks, as he editorialized with comments such as, "Ooh, hit a bone!" Halfway through the act, Burkhart would pry the spike out of his nose with the claw of a hammer, and explain: "It just goes to show you what some people will do to keep out of work." Snake charmers, sword swallowers, and the Rubber Girl — who survived inside a coffinlike box that was repeatedly punctured with knives — completed the menagerie of performers that comprised the death-defying acts of the circus sideshow.

UNFORTUNATELY, a number of sideshow performers were injured during their acts. As Meah explained, "After more than a dozen performances each day, people turned into zombies and as a result, accidents could happen, and they frequently did." The most common accidents, and the rare fatality, were associated with exploding neon tubes, used for ingestion by sword swallowers. Many of the tubes also contained mercury, which was both toxic to the nerve system and a powerful blood thinner that could produce internal hemorrhaging. Fire acts were known for producing facial burns, and on rare occasions, knife throwers missed their mark.

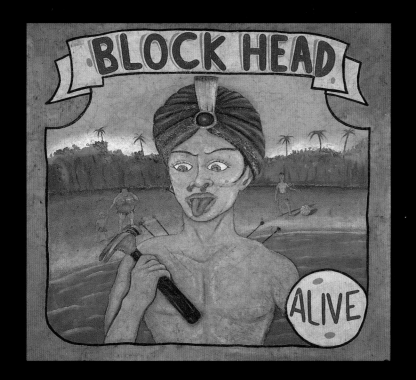

BLOCK HEAD
42"x45" c.1960s
COLLECTION OF MICHAEL
AND CINDY NOLAND

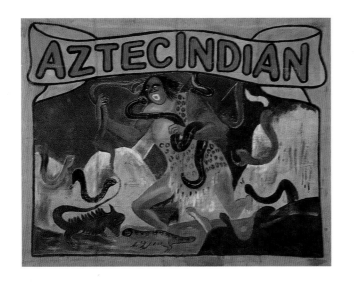

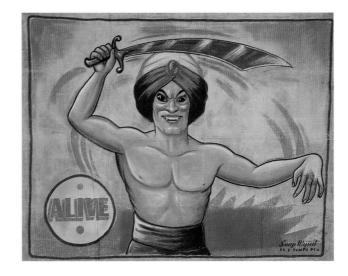

AZTEC INDIAN

90" x 114" c. 1940s

HINDU MAN

81-1/4" x 102-1/4" c. 1950s

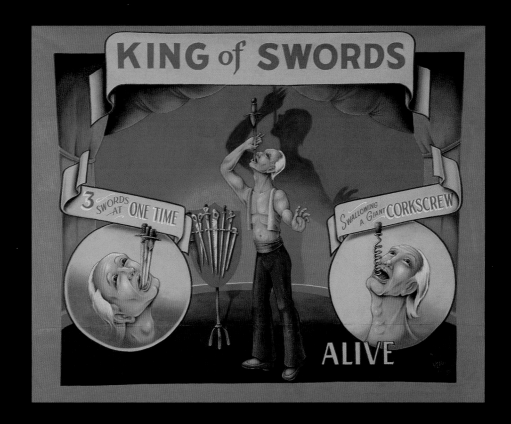

KING OF SWORDS
92"x111" c.1989

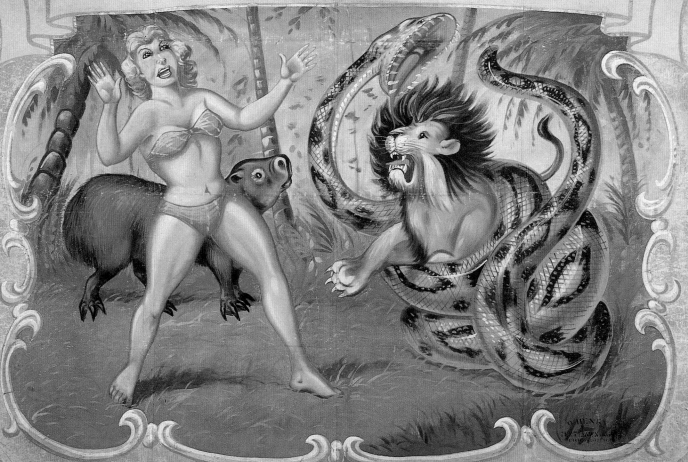

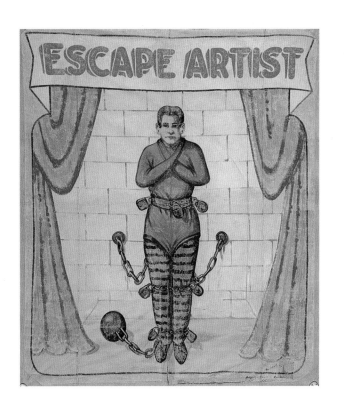

ESCAPE ARTIST
108"x93" c.1950-60
COLLECTION OF
CHARLES BOAS

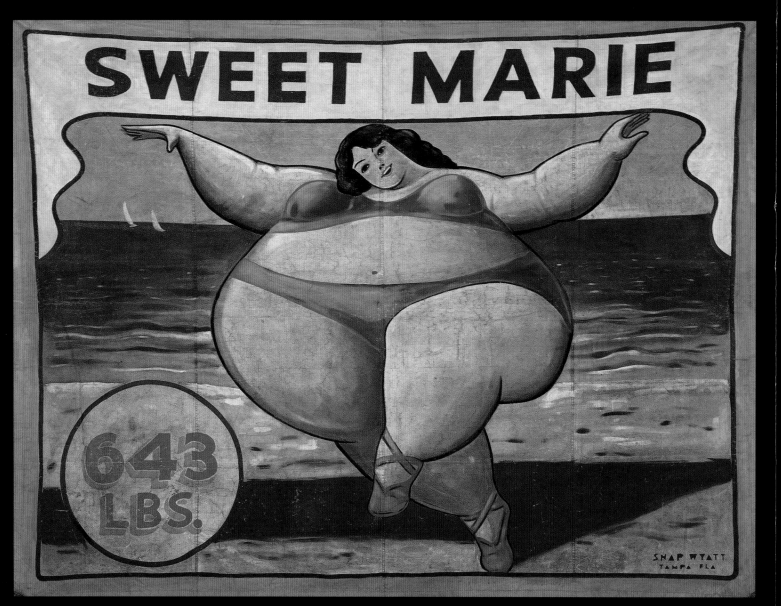

Sweet Marie **SNAP WYATT** *96"x120" c.1940s Collection of Lonnie Dillard*

BLIMPS AND SHRIMPS

LONG BEFORE OBESITY AND ANOREXIA WERE RECOGNIZED AS BONA FIDE MEDICAL DISORDERS, GIANTS, MIDGETS, BLIMPS, AND SHRIMPS CIRCULATED AMONG CIRCUS SIDESHOWS. CONEY ISLAND, FOR EXAMPLE, FEATURED "LILLIPUTIA," A PERFECT MINIATURE TOWN INHABITED BY THREE HUNDRED MIDGETS YEAR-ROUND. SAMUEL GUMPERTZ, A CONEY ISLAND PARK MANAGER, WAS KNOWN AS THE FATHER OF THE SIDESHOW. HE WAS ALWAYS ON

the lookout for record-breaking freaks, offering $200 per inch for every inch above the world's tallest man or for every inch below the world's shortest midget. Pete Moore, "The World's Smallest Man," stood at twenty-seven inches, a half-foot shorter than Ringling Brothers' Mishu, whom Guinness listed as the world's smallest adult human being. Moore met Adena Snyder, a woman of normal stature, at an Ohio fair in 1967. Eventually they married and had two children, one of whom inherited osteogenesis imperfecta from Moore, a bone condition that confined both the father and the daughter to wheelchairs.

GIANTS AND MIDGETS were respectable freaks. Prince Arthur, perhaps the most famous midget, was always presented to the public in finery, and he eventually became a wealthy man working for Barnum. His wife, Lavinia Warren, was also a midget who traced her lineage back to the Mayflower. Their wedding was an extravaganza, and the couple was lavished with gifts from the Vanderbilts, Tiffany, and President Lincoln.

THE MARRIAGE of dwarfs, giants, and fat people to each other was stock promotional strategy. But romantic matching between *opposites* generated even more interest. Pete Robinson and Bunny Smith married at a large ceremony in Madison Square Garden. He was Ringling's Living Skeleton Man, who was of normal height but weighed only 58 pounds. Bunny, in contrast, weighed 467 pounds. Promotional pictures showed Robinson trying to get his arms around Bunny, while in another image, Bunny held a dish, trying to feed her anorexic husband. But perhaps the world's strangest union belongs to Mr. and Mrs. Al Tomaini. Al claimed to be eight feet, four inches in height — in actuality, he was only seven feet, six inches tall — and Jeannie was of normal size, but was born without legs.

643 LBS.

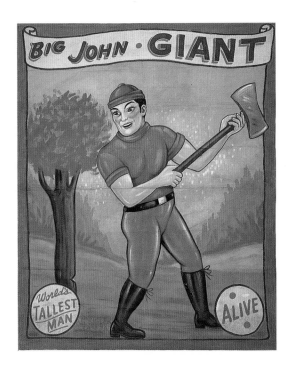

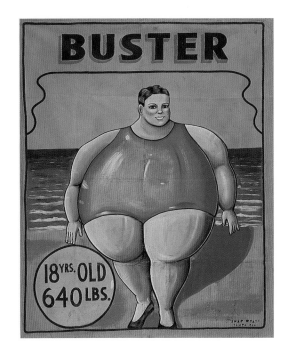

JACK CRIPE

BIG JOHN GIANT

141" x 115" c. 1979

COLLECTION OF

TEM HOROWITZ

SNAP WYATT

BUSTER

123-1/4" x 103" c. 1950-60

COLLECTION OF

JACK KRISTOF

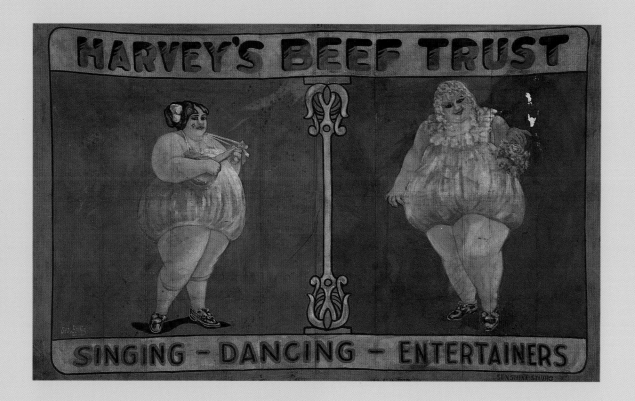

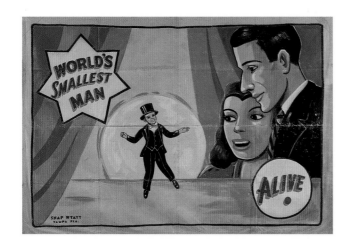

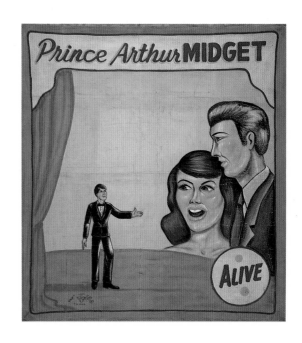

SNAP WYATT

WORLD'S SMALLEST MAN

81-1/2" x 118" c. 1950-60

JACK SIGLER

PRINCE ARTHUR MIDGET

113" x 105" c. 1960s

CIRCUS SIDESHOWS THRIVED UNTIL THE EARLY 1980S, AT WHICH TIME POPULAR INTEREST IN THIS FORM OF ENTERTAINMENT BEGAN A SLOW, STEADY DECLINE. 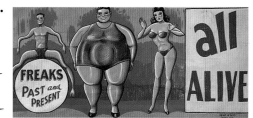 IN 1994, THE ONLY REMAINING SIDESHOW ACTS WERE BEING PRO-MOTED BY THE KELLY-MILLER TRAVEL-LING CIRCUS OUT OF HUGO, OKLAHOMA. "THIS RATHER ANEMIC SHOW," EXPLAINED JOHNNY MEAH, "CONSISTED OF WARD HALL THE FAT MAN AND PETIE THE MIDGET." STILL WORKING OUT OF MEAH STUDIOS IN RIVERVIEW, FLORIDA, MEAH IS THE ONLY LIVING BANNER ARTIST FROM THE HEYDAY OF THE CIRCUS SIDESHOW. A FEW STATE FAIRS AND CARNIVALS FEATURED WATERED DOWN VERSIONS OF THE SIDESHOW, BUT THESE CONSISTED PRIMARILY OF STAGE ILLUSIONS. BY 1995, THE CIRCUS SIDESHOW, WHICH ONCE FEATURED A BIZARRE MENAGERIE OF PERFORMERS AND MEDICAL ODDITIES THAT WERE "POSITIVELY, ABSOLUTELY ALIVE!" HAD DIED AN UNCEREMONIOUS DEATH.